Rip it!
Write it!
DRAW IT!

© 2015 Piccadilly (USA) Inc.

This edition published by Piccadilly (USA) Inc.

Piccadilly (USA) Inc.
12702 Via Cortina, Suite 203
Del Mar, CA 92014
USA

Some of the activities suggested in this book may not be appropriate for unsupervised children.

10 9 8 7 6 5 4 3 2 1

Printed in China

ISBN-13: 978-1-62009-835-6

Make a

page to yourself and describe in detail little things you're learning about yourself. Decorate the page in any way you want or keep it simple.

MAKE A

CHECKER BOARD PAGE.

THEN CHALLENGE A FRIEND TO A GAME OF
CHECKERS USING YOUR JOURNAL PAGE AS THE
PLAYING AREA. WRITE DOWN WHO WINS.

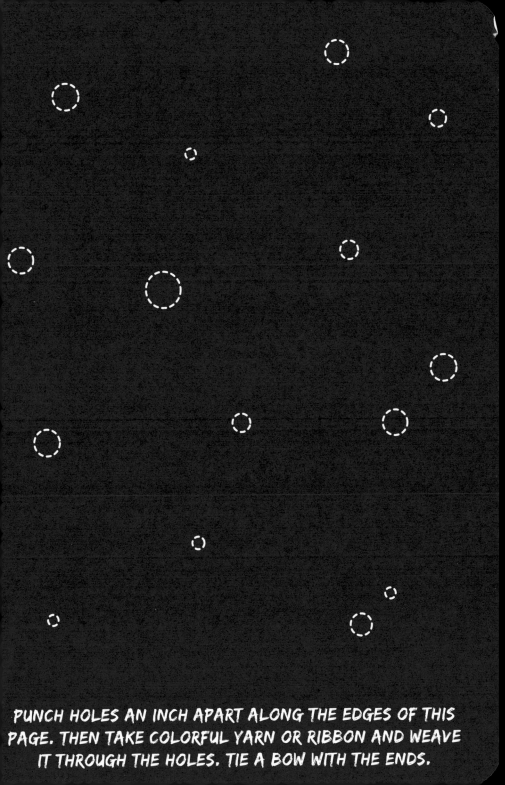

PUNCH HOLES AN INCH APART ALONG THE EDGES OF THIS PAGE. THEN TAKE COLORFUL YARN OR RIBBON AND WEAVE IT THROUGH THE HOLES. TIE A BOW WITH THE ENDS.

PLACE A STICKER (ANY KIND)
IN THE CENTER OF THIS
PAGE. NOW DRAW A STORY
OR BACKGROUND AROUND
THE STICKER AND THEN NAME
YOUR MASTERPIECE.

Make a treasure map on these pages.

Remember that X marks the spot in RED.

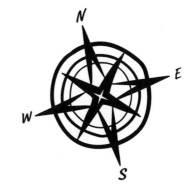

Collect random objects from places you eat out at for a week and then tape them on these pages. List the name of the place next to each item.

CREATE A "NOTE TO SELF" PAGE.
Write down things you would want to read 10 years from now.
Create important notes to carry throughout your life.

Drip candle wax
on this page and
leave it.

COPY YOUR FAVORITE SONG LYRICS
ON THIS PAGE IN ALL CAPS.

CREATE A "BEACH SCENE."
(BONUS POINTS IF YOU GLUE SOME SAND TO THE PAGE.)

PAGES OF FORTUNE

GO TO VARIOUS CHINESE RESTAURANTS
AND ASK FOR FORTUNE COOKIES. THEN
TAPE ALL THE FORTUNES YOU COLLECT
TO THESE PAGES.

Create a 50 questions spread. Write 50 questions you don't know the answers to but would like to know.

Collect business cards from places you like. Tape them on these pages and keep collecting until the entire two pages are full.

WRITE NICKNAMES FOR YOURSELF ON THIS PAGE.

Make a

using materials that will represent your family for future generations.

DRAW A MONSTER, GIVE IT A NAME
AND A SPECIAL POWER.

ZEBRA

DRAW A ZEBRA THEN COLLECT REAL GRASS AND GLUE IT UNDER THE ZEBRA.

CREATE A
PHOBIA SECTION.
LIST EVERYTHING YOU ARE
AFRAID OF AND WHY.

WRITE YOUR NAME IN TOOTHPASTE ON THESE PAGES.

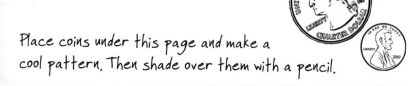

Place coins under this page and make a
cool pattern. Then shade over them with a pencil.

Take a photo of your journal and then tape the photo to this page. Draw lightning bolts around all sides.

Draw bubbles on these pages until you fill the entire page. Write a mixed-up message with a different word in each bubble.

WRITE A POEM DIAGONALLY ON THIS PAGE.

Make dots on this page and then connect them and try to make a picture.

Scratch this page
with tree bark over
and over.

Staple the edges of this page to create a border.

Collect as many signatures on these
pages as you can. Overlapping is
okay.

RUN OVER THIS PAGE WITH A TIRE OF SOME KIND, SUCH AS A BICYCLE OR WAGON TIRE. RUN OVER WAGON TIRE.

Attach safety pins to these pages – as many as you like.

WRITE THE ALPHABET BACKWARD IN LETTERS

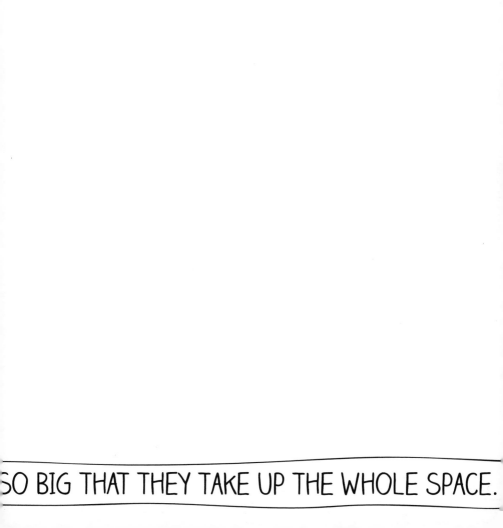

SO BIG THAT THEY TAKE UP THE WHOLE SPACE.

Create a polish spread.
Write the alphabet in shoe polish or nail polish.

COVER THESE
PAGES WITH
LEAVES.

Make it rain on this page. It can rain anything you like.

CREATE A SPELLING BEE PAGE. WRITE DOWN ((ORRE(TLY) AT LEAST 20 WORDS THAT GIVE YOU SPELLING TROUBLE. THE NEXT TIME YOU FORGET HOW TO SPELL ANY OF THOSE WORDS, VISIT THIS PAGE.

FIND A RECIPE
YOU LIKE AND WRITE
IT HERE. THEN TAPE AN
INGREDIENT OR A LABEL
FROM THE INGREDIENT
BELOW THE RECIPE.

Ask a friend or neighbor to write you a note on these pages.

DRESS THESE PAGES UP IN YOUR OWN STYLE.

MAKE THIS ENTIRE SPREAD A FLAG.

A FLAG THAT REPRESENTS YOU.

Paste a photo
of a light bulb, or
draw one, in the
center of this page.
Then write the best
or brightest idea
you've ever had
below it.

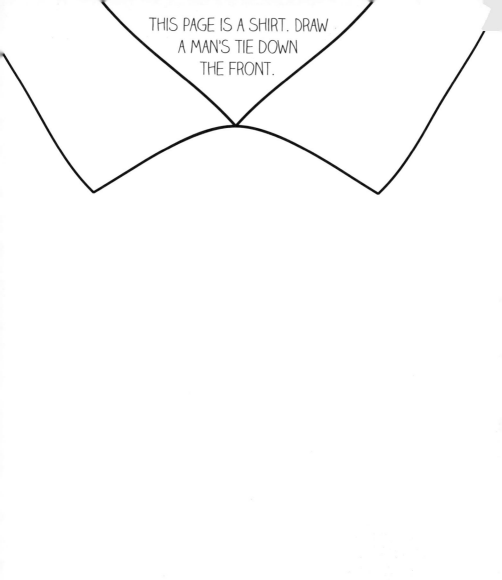

THIS PAGE IS A SHIRT. DRAW
A MAN'S TIE DOWN
THE FRONT.

Create "PETAL POWER" pages. Press, dry, and preserve several

types of flower petals here. Then gently paste them on the page.

Look around your
house to find
price tags and
price stickers.
Fill these pages
with them.

SMEAR
SOMETHING
GLOSSY
HERE.

CUT THE EDGES OF THIS PAGE TO MAKE FRINGE.

Smear this page with peanut butter, chocolate, or something sweet. Place it in the sun for 4 hours and let it bake.

Fill these pages with stars. Draw each one differently and don't let them touch each other.

Make a "save the planet" poster on this page. Imagine that it will be used as an ad and people all over the world will see it.

WRITE A SHORT STORY ABOUT A CACTUS HERE.
THEN DRAW RELATED ITEMS FOUND IN THE STORY AROUND THE EDGES OF THE PAGE.

 SKETCH A BOWL OF FRUIT USING COLOR PENCILS.

TRACE THE OUTLINE OF A PAPER SNOWFLAKE OR DRAW AN
OVERSIZED ONE THAT FILLS THE ENTIRE PAGE. THEN GENTLY
CUT OUT DETAILS OF THE SNOWFLAKE DESIGN WITHOUT
REMOVING THE PAGE FROM THIS JOURNAL.

Create a "get-inked" page.
Fill this page with stamps
from offices or other places
you visit. These should be
ink stampers - not postage
stamps. Each stamper must
say something different and
only be used once. Cover the
page with a variety of
stamp designs.

Make a "timeline" for your life on this page.

It can be horizontal or vertical, be sure to *star* major events.

CUT YOUR FAVORITE

CELEBRITY

OUT OF A MAGAZINE. PASTE THE PICTURE HERE
AND ADD DOODLES AND DRAWINGS.

Conduct a science experiment on this page.

Turn back to these pages when you feel like crying. Write down what made you cry. Then let your tears wash over the ink as they fall.

PRACTICE YOUR SIGNATURE. SIGN YOUR NAME IN 10 DIFFERENT STYLES HERE.

Make origami out of this page and tape your
creation to the front of this journal.

WRITE A
TABLE OF CONTENTS
FOR YOUR LIFE HERE.

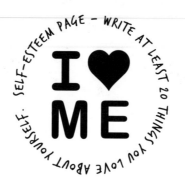

SELF-ESTEEM PAGE — WRITE AT LEAST 20 THINGS YOU LOVE ABOUT YOURSELF.

I ♥ ME

USE THIS PAGE AS A MIRROR AND DRAW YOUR REFLECTION.

Write a
POP QUIZ
on this page about yourself.

1. _____
2. _____
3. _____
4. _____
5. _____
6. _____
7. _____
8. _____
9. _____
10. _____
11. _____
12. _____
13. _____
14. _____
15. _____
16. _____
17. _____
18. _____
19. _____
20. _____

Have your friends or family fill in the answers on this page.

1.
2.
3.
4.
5.
6.
7.
8.
9.
10.
11.
12.
13.
14.
15.
16.
17.
18.
19.
20.

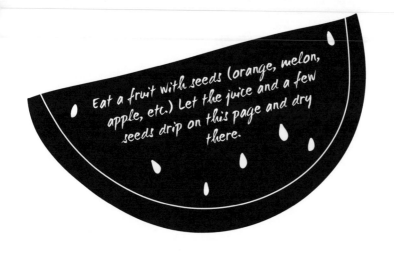

Eat a fruit with seeds (orange, melon, apple, etc.) Let the juice and a few seeds drip on this page and dry there.

HAVE AFTERNOON TEA ON THIS PAGE. SPILL A BIT AND TAPE THE WRAPPER FROM YOUR TEA BAG HERE. DESCRIBE THE TEA AND WRITE WHETHER YOU LIKED IT.

Sleep with this journal open
under your pillow. When you wake up,
write down the first thing you think
of or write down your
dream.

Create a **Collection** spread. Collect somethi

...at's unusual, small, and flat. Paste your collection on these pages.

PRESS HARD, & FILL THESE ENTIRE PAGES.

Make a
greeting
card here for
a long lost
friend or
family member.

DRAW A FLAME WITHIN A FLAME, WITHIN A FLAME, WITHIN A FLAME. MAKE AT LEAST 4 FLAME LAYERS AND EACH FLAME LIGHTER THAN THE LAST.

GET A BOX OF CRAYONS AND GO WILD ON THESE PAGES.

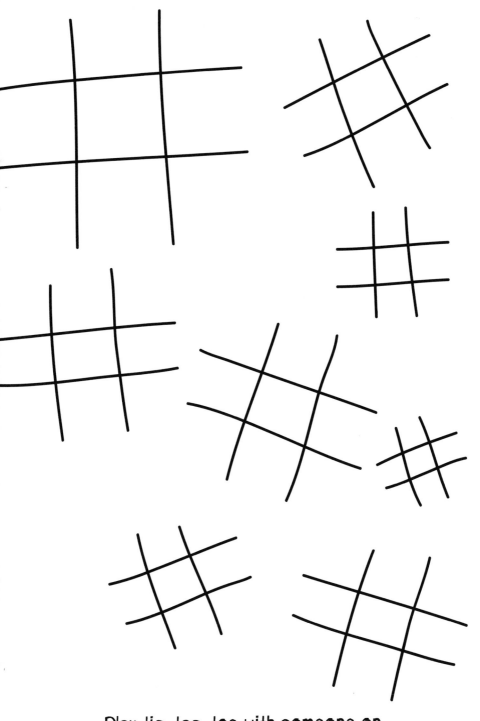

Play tic-tac-toe with someone on
these pages until they're full.

CLIP SOME BUTTONS OFF OF ANYTHING AND GLUE THEM HERE.

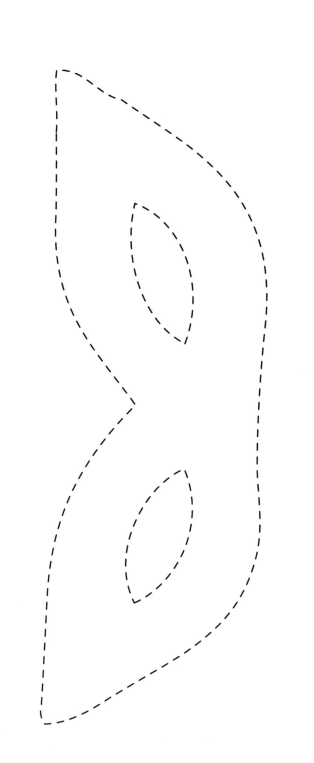

Make a mask out of this page, decorate it, wear it, and put it back when you're done.

COLOR THIS PAGE USING ONLY HIGHLIGHTERS.

MAKE THIS PAGE LOOK LIKE A STAINED GLASS WINDOW

CREATE A PAINTING IN THE STYLE OF JACKSON POLLOCK BY SPLATTERING RANDOM SUBSTANCES HERE.

CREATE A BAND-AID COLLECTION.

STICK BAND-AIDS OF ALL DIFFERENT SHAPES, SIZES, COLORS, AND DESIGNS (CARTOONS ARE GREAT) TO THESE PAGES. COVER THE PAGES WITH YOUR COLLECTION. USE CLEAN BAND-AIDS ONLY. IT MAY TAKE A WHILE - BE PATIENT.

Rub these pages on your lawn.

Get them earthy.

Make this page *glow* in the dark!

Sharpen a
pencil on this page
and glue the
shavings here.

DRAW A
TREE
ON THESE PAGES
BUT DON'T
DRAW THE
BRANCHES
YET. EACH TIME
YOU HAVE
A MAJOR
"LIFE EVENT"
(LIKE GRADUATION),
COME BACK AND
DRAW A BRANCH.
WRITE
THE LIFE
EVENT ON THE
BRANCH.

TAPE A QUARTER TO THIS PAGE. NEVER UN-TAPE OR SPEND THIS QUARTER.

To:

From:

Write a love letter to your secret crush here.

MAKE THESE PAGES MESSY. THERE ARE NO RULES — LET LOOSE.

COLOR
THESE
PAGES

USING
YOUR
FEET.

P A R T Y

MAKE THESE PAGES FEEL LIKE A BIRTHDAY PARTY.

Create throwback pages. Tape a photo from any time in your childhood to this page. Then write about what you were doing in the photo and your age.

List flavors of ice cream on this page. Fill the page and use a different color of ink for each flavor.

Shhh!

WRITE A SECRET ON THIS PAGE. THEN FOLD THE PAGE IN HALF
(VERTICALLY), GLUE THE EDGES SO NO ONE WILL SEE IT,
AND WRITE KEEP OUT ON THE FOLDED PART.

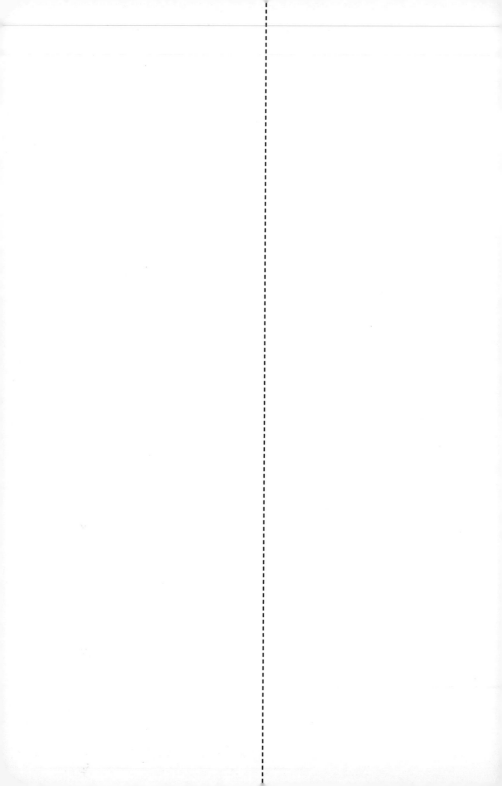

Make a scratch-and-sniff page here.

DRAW A HALF MOON ON THIS PAGE.
THEN CUT OUT THE MOON WITHOUT
REMOVING THE PAGE.

Make a chalk outline of something on this page. **!**

COVER THESE PAGES WITH STRIPS OF TAPE.

YOU CAN USE DIFFERENT KINDS OF TAPE.

Crush
something on
these pages.
Make it
artistic.

Take these pages outside when it rains,
use them as an umbrella.

Then go inside and write about how you felt in that moment. Yes, these pages will still be wet.

GIFT WRAP THESE PAGES WITH YOUR FAVORITE
WRAPPING PAPER. INCLUDE A GIFT TAG.

♥ ♥ ♥ ♥ ♥ ♥ ♥ ♥ ♥ ♥ ♥ ♥ ♥ ♥ ♥ ♥ ♥ ♥

show the
LOVE
♥ ♥ ♥
write down all
the things
you love
here.

♥ ♥ ♥ ♥ ♥ ♥ ♥ ♥ ♥ ♥ ♥ ♥ ♥ ♥ ♥ ♥ ♥ ♥

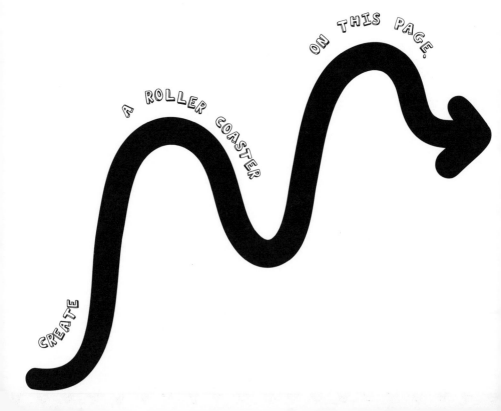

CREATE A ROLLER COASTER ON THIS PAGE.

FILE THIS PAGE WITH A FINGERNAIL FILE.

RUB A STRAWBERRY OR BEET ON THIS
PAGE AND SEE IF IT TURNS RED.

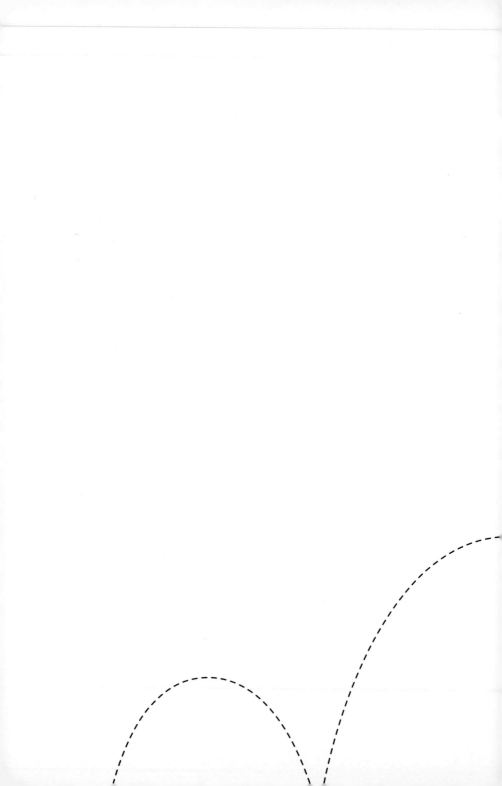

Play ball on these pages (tennis, basketball, Ping-Pong, etc.). Oh, and be sure to get the ball muddy.

Create vacation pages. Draw a picture of the places
you most want to go on vacation. Use only pencils.

>>>>>> *Make a*

PIE CHART

for your life on these pages. >>>>>>

BE DETAILED

and use colors to separate the sections.

INCLUDE PERCENTAGES.

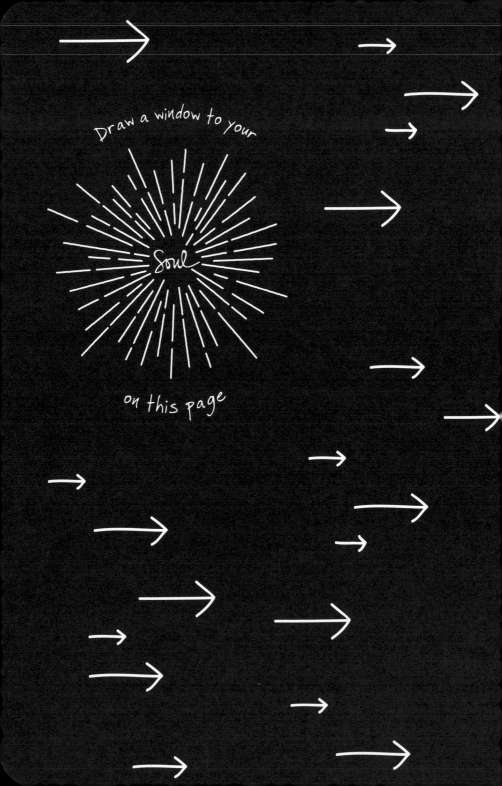

Draw a window to your

Soul

on this page

Color this page in THICK silver crayon (or any other color). Then take a penny and draw stuff in the crayon wax.

Make a crossword
p
u
z
z
l
e on this page.

TAPE A PICTURE OF SOMEONE
WHO INSPIRES YOU AT THE
CENTER OF THE PAGE.

THEN WRITE WORDS TO
DESCRIBE HOW THEY MAKE YOU
FEEL ALL AROUND THEIR PHOTO.

DRAW ARROWS ON THIS PAGE —
ANY DIRECTION, ALL OVER.

BLACK OUT THIS PAGE.

Write a message
to yourself
so small that
it's impossible
to read.

WRITE ON THESE PAGES WHEN YOU'RE EXCITED!
DESCRIBE WHAT IT FEELS LIKE.

Place labels here from food, clothes — anything.

DRAW A "PAINT BY NUMBERS" PAGE, INCLUDE ALL NUMBERS & COLORS NEEDED.

NEWS

Tear out today's
newspaper headline, tape
it to these pages, and
then write how you feel
about it.

LOOK SURPRISED.

Sketch someone or something in pencil.

use shading and shadow effects.

MAKE SOMETHING **COOL** ON THESE PAGES USING ONLY FREE SAMPLES

YOU FIND (SUCH AS FREE PAINT SWATCHES FROM A HARDWARE STORE).

TAKE THESE PAGES ON A RUN OR WALK. DOCUMENT THE JOURNEY, INCLUDING

HOW FAR YOU WENT, WHAT YOU LISTENED TO, AND THE SCENERY.

Write fun equations on this page (for example: cookie + milk = happiness). Create at least 5.

Decorate this page for the Easter Bunny,

DRAW DOMINOS ON THIS PAGE

(KEEP IT BLACK AND WHITE).

Smash your favorite chips or crackers on this page.

 HAVE A RACE BETWEEN A MARKER AND PEN. WRITE WHO WINS AND WHY.

Cover these pages with squiggly lines, lines, and more lines.

CREATE A NEW INVENTION. DESCRIBE IT.

MAKE A "FEEL GOOD" PAGE WITH POSITIVE QUOTES.

☐ Write down your goals on these pages.

☐ In front of each goal, draw a square box big enough for a check mark.

☐ When you complete a goal, make a BIG red check mark in the box beside that goal.

☐ Don't worry — it's just for motivation. It may take time to complete these pages.

BLOW UP
BALLOONS, POP
THEM, AND
TAPE THE PIECES
HERE.

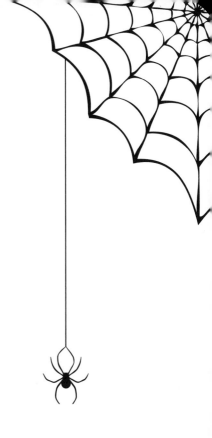

MAKE THESE PAGES LOOK LIKE A SPIDER WEB.
FILL THE ENTIRE SPACE.

MAKE THIS PAGE ECHO.

MAKE THIS PAGE ECHO.

MAKE THIS PAGE ECHO.

MAKE THIS PAGE ECHO.

MAKE THIS PAGE ECHO.

TEAR THE EDGES OF THIS PAGE RANDOMLY WITHOUT TEARING OUT THE PAGE.

Sorry!

Sorry!

SORRY!

Sorry!

Sorry!

Create an apology page. Write at least 3 apologies you owe people. Write why you owe each person an apology and who you owe it to. You don't have to apologize to the person; thinking about it is a great place to start.

 Open these pages when you're mad and take out

your anger on these pages.

THESE PAGES NEED TO BE RED. BE CREATIVE, AND

YOU MAY NOT USE A PEN, PENCIL, MARKER, CHALK, OR PAINT.

WRITE **"I WILL WRITE IN THIS JOURNAL"** EVERY
DAY ON THIS PAGE UNTIL YOU FILL THE ENTIRE PAGE.

Make a giant spiral. Start at the center of the page and keep going until you run out of room.

CREATE YOUR DREAM
BOARD ON THIS PAGE USING
MAGAZINE CLIPPINGS.

WRITE YOUR FAVORITE MOVIE HERE. WRITE
MEMORABLE SAYINGS FROM THE MOVIE
ON THIS PAGE, TOO. USE BLUE INK.

 DRAW A GIANT SUN IN YELLOW OR ORANGE. THEN WRITE YOUR FAVORIT[E]
SUMMER MEMORY IN THE CENTER OF THE SUN.

WRITE

BELIEVE IN
YOURSELF

ON THIS PAGE.

Take your journal on a picnic. Document where you go, all the events, and what you ate on the picnic. Tape a memento here.

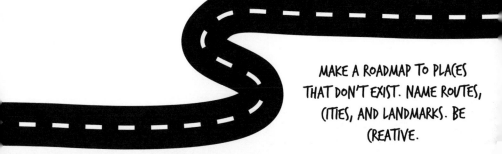

MAKE A ROADMAP TO PLACES THAT DON'T EXIST. NAME ROUTES, CITIES, AND LANDMARKS. BE CREATIVE.

WRITE A "ROSES ARE RED" POEM HERE.
YOU MUST CREATE THE POEM.

GET THIS PAGE
CAUGHT IN A
ZIPPER.

Close your eyes. Draw the first thing that comes to mind while keeping your eyes closed.

DEDICATE THIS PAGE
TO SOMEONE.
WRITE WHY.

MAKE THESE PAGES
FUTURISTIC.

DRAW YOUR EYES ON THIS PAGE.

BE DETAILED.

MAKE A CLOCK ON THIS PAGE.
REMEMBER TO SET THE TIME.

DO SOMETHING WITH SPONGES ON THESE PAGES.

MAKE YOUR ELBOW COLORFUL
AND THEN RUB IT HERE.

COVER THIS ENTIRE PAGE WITH GLUE. SPRINKLE GLITTER, CONFETTI, SPRINKLES, ETC.

FILL THIS PAGE WITH AS MANY WORDS THAT RHYME WITH "CAT" AS YOU CAN THINK OF.

Write a wish list for the world on this page.

WASH YOUR HAIR WITH SHAMPOO AND
THEN RUB THE LATHER ON THIS PAGE.
WRITE THE NAME OF THE SHAMPOO
IN THE CENTER.

 Draw a giant 4-leaf clover and color it green. Then list all the times you've been lucky in your life below it.

Write a message that has to be decoded. Leave
clues below the message about how to decode it.

WRITE *The End* IN RED AND THEN LIST 3 ACTIVITIES YOU
WISH YOU'D DONE WITH THIS JOURNAL.